A Bit of a Bumble!

An affectionate look at the Dorset dialect

Alan Chedzoy

with illustrations by Richard Scollins

COUNTRYSIDE BOOKS
NEWBURY BERKSHIRE

COUNTRYSIDE BOOKS
3 Catherine Road
Newbury, Berkshire

To view our complete range of books,
please visit us at
www.countrysidebooks.co.uk

ISBN 1 85306 806 3

For Bonny Sartin and the Yetties

Designed by Peter Davies, Nautilus Design
Produced through MRM Associates Ltd., Reading
Typeset by Techniset Typesetters, Newton-le-Willows
Printed by J. W. Arrowsmith Ltd., Bristol

CONTENTS

FOREWORD

Visitors to Dorset will often hear traces of dialect in the local villages, pubs and clubs. An old man will say that he's 'goen on, then,' or ask where his friend is 'goen to'. Or his wife will say she 'can't be doen with all that', or complain that everything's in a 'caddle', or observe that its getting fair 'dumpsy' outside.

These are scraps of the dialect which was once common throughout the West Country but is now chiefly restricted to older people and the more remote areas. Sometimes, however, a Dorset word will suddenly come into modern national usage, like the word *dumbledore*, which means 'bumble bee', and is now the name of a Harry Potter character.

Perhaps it is from the stories of Thomas Hardy (1840-1928) that people are most aware of the Dorset dialect and some passages of Hardy's dialect are printed on the following pages.

You will find also an introduction to the dialect; a simple guide to speaking it; lists of dialect words concerning the farm, animals and plants, ghosts and monsters, and terms from the Portland stone quarries, as well as expressions from everyday life. And if you want to know something of annual Dorset festivals from previous days, or old customs, you will find them here. Add to all this some jokes, comic dialect stories and poems from Hardy, William Barnes, Robert Young and 'Skylark' Durston, and you have a fair representation of the language of Dorset.

This little book is intended as a window through which may be heard the old Dorset dialect; or a family party to which everyone, friend and stranger, is welcome. I hope that you will enjoy it, and that this brief acquaintance with the Dorset dialect will give you as much fun and lasting pleasure as it has given me.

To savour the full rich flavour of the dialect, and aid understanding, try reading the stories and poems aloud; to perfect the finer points of pronunciation you may find it helpful to refer to the following audio tapes:

Thomas Hardy: Selected Poems
read by Alan Chedzoy, Canto, ISBN 1-903515-05-X
William Barnes: Selected Poems
read by Alan Chedzoy, Canto, ISBN 1-903515-04-1

<div align="right">

Alan Chedzoy
Weymouth, 2003

</div>

CHAPTER 1

An Introduction to the Dorset Dialect

The *Concise Oxford Dictionary* defines a dialect as a 'manner of speaking, language or speech' peculiar to an individual or class, or a 'variety of speech differing from standard language' often arising from local peculiarities. Certainly, dialect is speech. A written specimen is an oddity and only occurs when a collector such as William Barnes wishes to record its peculiarities. A dialect comprises:

(a) Its own vocabulary (or *lexis*) with words that do not appear in standard English.

(b) Its own grammar. (Though many of those who speak the Dorset dialect are unaware of it, their speech obeys certain grammatical rules, derived from older languages.)

(c) Its own special pronunciation.

Dorset (this is the name of a language as well as a place) exhibits all these features.

(a) Vocabulary

Many Dorset dialect words seem to have been common throughout the county and even beyond. Examples include: **plim** 'to swell', **emmet** 'ant', and **vinny** 'veined' (as in blue vinny cheese).

Often such words derived from particular occupations, and, as agriculture was common throughout the county, so was the language associated with it. Words such as **tedding,** which meant the spreading of hay to dry, and **pooks,** which were the large cones onto which the hay was loaded, were familar to Dorset dwellers as far apart as Blandford and Weymouth, Bridport and Poole.

Other words were confined to particular areas, such as **kimberlin** from Portland, which signifies anyone who does not come from that island. Even more specialised was the vocabulary used by certain tradesmen, such as the ball-clay miners of Purbeck or the stone-quarrymen of Portland. Purbeck men called square stones **pitchers,** while on Portland, chips of stone were known as **spawls.**

In years gone by many middle-class people regarded the Dorset dialect as an

ignorant speech, a sort of rough mumbling by country labourers who were not intelligent enough to grasp the nature of standard English. The curious words they used, such as **ninnywatch**, were a puzzle to newcomers and sometimes matters for ridicule even among local townsmen.

(b) Grammar

The Dorset poet, William Barnes, showed that the dialect derives much of its grammatical structure and vocabulary from Old English and other Germanic languages.

(c) Accent

The Dorset accent has much in common with other west-country speech but, like the vocabulary, exhibits local variations. There are distinctions even between places as close as Dorchester and Weymouth (8 miles). Generally speaking, the further south one goes in the county, the more people speak with an open mouthed *aah* sound, whereas in the north, towards the Somerset border, the rolled *r* and *ur* sound comes into prominence.

DORSET SPEECH

Much of what is regarded as Dorset dialect is not peculiar to the county but shares features with other south-western counties, especially Somerset and Wiltshire. Individual speech manners do not change abruptly at an arbitrary administrative boundary, though a natural obstruction such as a river or range of hills might result in abrupt differences. Consequently, there are many dialectical features shared throughout the south-western counties. For example, the Dorset poet Robert Young wrote in **Fippen Okford Diggens**:

> Here's work, my lads, agwain on,
> I never heard the like;
> They say at Fippen Okford
> There's goold in every crick;
> An' mwore than that they zay bezides
> There's lots o'cwoal an' iron,
> An' twon't be long avore we git
> A little cheaper viren.

Whilst Edward Slow, a Wiltshire poet, wrote in **Smilin Jack**:

> Thease story I be gwain to tell
> Is certain true, I mines un well,
> It happened wen I were a bwoy,

> *In pinafores an' carderoy;*
> *Var broad cloth wurden wore much then*
> *Be leetle bwoys, nar neet by men.*

Clearly, these two writers belong to the same linguistic community. There are some differences; most Dorset people of the time would not have said **leetle**, but **liddle** or even **vooty**. But the similarities are much stronger. Both poets write **an'** for 'and', and employ a *w* before a vowel as in **agwain** and **bwoy**.

Nevertheless, even within the county, varieties of speech forms have been observed, and on occasion classified as separate dialects. R.J. Saville claims to have identified three different Dorset dialects, namely those of Purbeck, Dorchester and North Dorset. It may be doubted, however, whether very local peculiarities of speech properly constitute separate dialects. It is true that in secluded areas such as Purbeck, Portland, the Blackmore Vale and the Marshwood Vale, in former times the common speech tended to develop particular mannerisms, but the inhabitants of these various areas would have understood each other. By contrast, a visitor from London might have found the language spoken in any of these places quite incomprehensible.

In the larger more urban areas of Dorset, which were in contact with the wider world, the dialect was and is less pronounced. Inhabitants of the important port of Poole, with its trade with Newfoundland, and of the 'royal' resort of Weymouth, which was popularised by King George III, were familar with a more cosmopolitan speech, than were those of the remote valleys of the north and west.

THE WORK OF WILLIAM BARNES

No account of the Dorset dialect could omit reference to the pioneering work of William Barnes (1801–86). He was a dialect poet, antiquarian and linguist. Born at Bagber near Sturminster Newton, he lived most of his adult life in the Dorchester area. He was the proprietor of several private schools, and for the last 22 years of his life the rector of the little parish of Winterborne Came, near Dorchester.

Though an educated man and in later life a clergyman, Barnes could never forget the culture and language of the labouring people in the Blackmore Vale, among whom he had grown up. When in his thirties, he began to publish in the *Dorset County Chronicle* poems written in the Blackmore dialect, which celebrated the customs and lives of his own people. In 1844 he collected them in a book which came out with the title *Poems of Rural Life in the Dorset Dialect,* and he continued to write and publish his dialect poems for many years afterwards. Thomas Hardy considered Barnes to be 'probably the most interesting link between present and past forms of rural life that England possessed'. In these

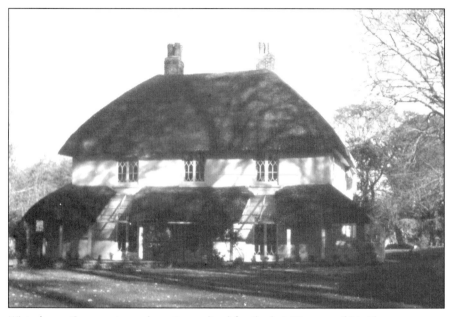

Winterborne Came rectory where Barnes lived for the last 22 years of his life

poems is preserved a record of the lives and language of generations of Dorset people.

The *Poems of Rural Life* had necessarily included a glossary of dialect terms so that genteel readers could understand them. It was printed in sections in the *Dorset County Chronicle* with an appeal for further contributions from readers living around the county. From this material Barnes eventually published his *Glossary of the Dorset Dialect with Grammar* in 1863, reprinted 1886, in which he collected hundreds of words and expressions which were in danger of disappearing. This extraordinary book has been the starting place for all subsequent accounts of the Dorset dialect, and this little book frequently draws upon it.

During the Victorian period there was a widely prevalent view among middle-class and professional people that the language of rural labourers was 'something in the nature of a jumble of mispronounced or corrupted words borrowed from standard English'. Such opinions were strongly disputed by Barnes. He tried to show that, far from being a debased form of standard English, the dialect of the western counties was in fact the closest contemporary speech to the Old English spoken in the western counties when Alfred was King of Wessex in the ninth century.

An inspection of the origins of just a few words makes the point:

Dialect	Old English	Modern English
a-gean	ongean	again
a-vrore	gefroren	frozen
brimmel	bremel	bramble
leer	leer	empty
parrick	pearroc	paddock
(h)rathe	hrathe	early
wops	woeps	wasp
zull	sulh	plough

So when a labouring man claimed he had been stung by a 'wops', it was not because he was too stupid to pronounce the word 'wasp' correctly; it was because he was still using the Old English word. And his apparent misplacing of prefixes when he said 'onless', 'onpossible' and 'inobedient' in fact drew upon words which are to be found in *Piers Plowman* and early English versions of the *Bible*.

Because Barnes was a linguist, who had taught himself to read over seventy languages, he was able to explore the close relationship between the Dorset dialect and Old English, as well as with other tongues such as Swedish, High Dutch, Low Dutch and Friesian. Dorset, he argued, not only had a vocabulary but also a grammar derived from roots in these languages. An example may be taken from the present tense of the verb 'to be'.

Dorset	Old English
I be	ic beo
thou bist	thu bist
he is	he is
we be	we beoth
you be	ge beoth
they be	hi beoth

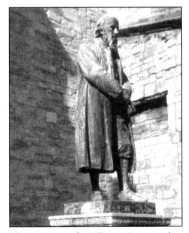

According to Barnes, the humblest ploughman or shepherd who retained elements of Anglo-Saxon in his speech, was probably employing a better, simpler English than the 'educated' language spoken in the squire's house, which had been permeated by

The statue of William Barnes that stands outside St Peter's church, Dorchester

foreign tongues such as Latin and French. He even speculated that, had not the capital of England been shifted from Winchester to London, the dialect of the people of Wessex would have been the dominant tongue, the standard speech for all England.

In his many publications on language, Barnes defended the view that the dialect was superior to standard English because it was not only 'purer', but was also simpler, more widely understood, closer to the real lives of men, often more accurate and certainly more pithy. He advocated the continued use of the dialect in order to provide a further dimension of meaning to standard English. For example, the word 'shelter' meant screening from something falling such as rain or hail, but the dialect word **lewth** referred specifically to screening from a cold wind. Barnes suggested that there should be a return to the dialect wherever possible. He even attempted to invent plain dialect terms to replace the Latinate names given to new inventions; *perambulator* should be replaced by *baby-cart* and *photograph* by *sun-print*. One critic marvelled at the 'madness of an almost unknown man' trying to revive the dialect and turn the English language away from the direction in which it was going.

(In this book, material from William Barnes will be marked WB.)

FOLKLORE

Dialect is intimately connected with the life of the people, and contains many echoes of Dorset society of former times, of its work, customs, traditions, religion and amusements. For example, a feast day was called a *tide*, a word still preserved in the dialect, but only appearing in standard English in such expressions as *Eastertide* and *Christmastide*. Over the years, many of the connections with the medieval Catholic church were forgotten but would still surface in the names and customs of the annual festivals. *Shrovetide* originally signalled the brief interval of merry-making between confession and the rigours of Lent.

So it is that the dialect spoken throughout the western counties for the three centuries between the birth of Shakespeare and the age of steam afforded a copious record of the life of the people. But the coming of the railway changed everything. Thomas Hardy remembered that, within a few weeks of the arrival of the railway in Dorchester, the old folk tunes of the country people had given way to music-hall songs popularised by the printed music sent down from London.

THE DIALECT TODAY

As in other counties, the rural dialect is disappearing. Writing in 1908 Thomas Hardy complained that the dialect recorded by Barnes was fast dying out, and 79 years later James Attwell was able to reflect that though he was brought up in

Chantry House in Wiltshire where Barnes ran a school

Barnes's area, only about one in ten of the words the great man had recorded in his glossary remained in common use.

The reasons for such a decline are well recorded. Hardy blamed the teaching of standard English in the village schools of his day. Since then, the pressures on local speech have grown enormously: easy communication with the great cities, the press, film, television and radio have all played their parts in diluting local speech, as have tourism and the purchase of holiday homes by people from beyond Dorset. Even within the county, what is called 'estuary English' is now widespread, and younger people may be heard speaking with that curious terminal lift to their sentences which they have absorbed from Australian TV soaps.

But still traces of the dialect remain, especially among older people, among working people, and in the shops, farms and small-holdings in the north and west of the county. In recent times, James Attwell has recorded the speech of north Dorset, Sylvia Creed that of the Marshwood Vale, R.J. Saville that of Purbeck, and Irene A. Eady that of Puddletown in mid-Dorset. Like Barnes and Hardy before them, they recognise that in the Dorset dialect we possess a treasure trove of folk history and vivid English expression. It must not be forgotten.

Meanwhile, we can all help to keep the dialect alive. Readers of this book may like to drop the occasional dialect term into their own language; to call a young girl a *maid*, or a magpie a *chattermag'*. As John Keats said, English must be kept up. To help in this, there follows a not altogether serious guide to speaking Dorset.

THE DORSET ANTHEM

Barnes wrote the poem 'My Orcha'd in Linden Lea', which, in the musical setting by Ralph Vaughan Williams, has become the unofficial Dorset anthem and is frequently sung on Dorset occasions. Curiously enough 'Linden Lea' is not in the county. It is the fictional name Barnes gave to Chantry House at Mere, Wiltshire, where he ran a school for some years.

My Orcha'd in Linden Lea

'Ithin the woodlands, flow'ry gleaded,
By the woak tree's mossy moot,
The sheenen grass-bleades, timber-sheaded,
Now do quiver under voot;
An' birds do whissle overhead,
An' water's bubblen in its bed,
An' there for me the apple tree
Do lean down low in Linden Lea.

When leaves that leately wer a-springen
Now do feade 'ithin the copse,
An' painted birds do hush their zingen
Up upon the timber's tops;
An' brown-leaved fruit's a-turnen red,
In cloudless zunsheen overhead,
Wi' fruit for me, the apple tree
Do lean down low in Linden Lea.

Let other vo'k make money vaster
In the air o' dark-room'd towns,
I don't fear a peevish master;
Though no man do heed my frowns,
I be free to goo abroad,
Or teake agean my hwomeward road
To where for me, the apple tree
Do lean down low in Linden Lea.

A Bit of a Bumble

or A Dorset gentleman meets an old villager (after WB)

Villager 1: There, sir, the p'liceman twold I zome'hat that put me in a terr'ble ninny-watch.

Gentleman: And what's that?

Villager 1: Well, sir, I'd 'low, 'tis trouble.

Enter Villager 2.

Gentleman: Did you ever hear of a ninny-watch?

Villager 2: O, ees, sir, I've often a heard en tell o't.

Gentleman: Well, what does it mean?

Villager 2: I'd 'low 'tant got noo meanen, sir; 'tis only oone o' they words we poor folk do use.

Gentleman: This old man here tells me it means trouble.

Villager 2: Trouble, sir? Dwoant mean trouble noo mwore than do mean Richard.

Gentleman: Well, then, how do you use it?

Villager 2: Well, sir, if I've a-zeed anybody in ar-a-bit of a bumble about his work – a peepen about, in a kind of stud like – I've a-heard em say 'What be you got a ninny-watchen about?'

CHAPTER 2

Getting by in Dorset

So you are going to Dorset! Whether you are just passing through or planning a stay there, you will get so much more out of your visit if you can say a few words to the locals in their own language. You will probably get better service in shops, pubs and hotels if you can explain your simple wants, for tent pegs, lardy cake or chitterlings, etc. in the local argot. Here are a just a few tips to help you to geh-by 'n Darzet! **Remember: Dorset is not just a place; it is a language.** (*D'yer min' lik, Darzet's nary a pleace, 'tis a lingo too.*)

When you meet a friend you should say: **Awri then?** (literally: 'Are you all right, then?'), but you are not really asking after his/her health. You are saying 'Hello'. Because this is not a true request for information, you do not tell them how well you are. The answer is not 'Yes' or 'No'; the correct reply is: **Awri ?** But pitched a note higher.

Now, practise the complete conversation with a friend:

Awri then?

Awri?

Practise it a little every day and you'll soon be word perfect.

Another way in which to say 'Hello' is to refer to the time of the day: **marnen, ar'ernoon, evenen** or **evemen.**

When parting you should say **Zoolong** or **Z'long**, which means 'I hope that it will not be so long (as it has already been) before we meet again'.

Yes and No

'Yes' is easy: it is **ees**, (Dorchester/West/North Dorset) or **aah** (Purbeck) or **aarr** (near the Somerset border). Sometimes it is supported by an added expression: **aa 'tis** or (speculatively) **mid be.**

But in Dorset the word 'noo' (no) is rarely uttered. Such a word would be considered too blunt, even downright rude. Instead there is a range of expressions which might be used, such as **doan' reckon**, **nod 'zacly**, **nod's you say**, **nod's beak of**, etc.

Qualifiers

Dorset rarely states anything as an outright fact. Such bluntness would be reckoned impolite. Instead, assertions are offered as mere possibilities which might well be wrong. A statement such as '**T'is a nice day**' will usually be offered with an immediate qualifier such as the word 'like' put on the end. There are three chief terminating qualifiers, though others are sometimes heard:

(a) **T'is a nice day, lik.**
(i.e. 'It is a bit like a nice day, sort of, though I wouldn't say so absolutely.')
(b) **T'is a nice day, min'.**
(A note of caution here; *min'* means 'mind', 'mind you', or 'Do you call that to mind?', i.e. 'Have you noticed?')
(c) **T'is a nice day, d'yer see?**
(Explanatory, or a bit argumentative, a bit impatient: 'Surely you understand that?')

These terminators may be attached to almost any sentences, statements or questions:

Was ee wan, lik?
'Er be schoolmaster, min.
He do varm, d'yer see?

Now, practise the terminators at the end of any sentence in English.
You see? You are beginning to talk Dorset.

Some common verbs

(a) *to do*

This is the most important verb in Dorset speech. It appears in hundreds of sentences, always preceding the main verb. Its pronunciation varies according to area of the county and social status of the speaker, e.g.

He do see me coming.
'E der zee me comen.
'E der zee oi comen.

She do take on so.
She der tak on zo.
She d'tak on zo.

I der wamble roun' the parish.
She der slap Sammy 'cross's chops.

When trying to talk Dorset, you are best advised always to slip in a do/der/'d before the main verb. It will give your talk that 'rustic' sound.

(b) *a* is nearly always prefixed to participles. (It replaces the *y* or *i* in Old English, e.g. 'Sumer is icumen in'.)

past participles:
Wife a-lost
He'm a-spoke
Wol hoss have a-rambled vur an' wide.

present participles:
He be a-comen.
Her allus be a-werreten. ('She's always worrying.')

(c) *to be*

present tense

I be	we be
you be	
he be, she be,	t'is, they be

past tense

I were	we were
you was	you was/were
he were,	
she were	t'were

Arguments depend on this verb. If you want to enjoy a good dispute in the bar of the King's Arms in Dorchester, you need to know the basic forms for assertion and negation:

Exercise A: Assertion: **'T'is**
Negation: **'Tidden'** (or, more rarely, **t'ain**)

Exercise B: Assertion: **Was** or **Were**
Negation: **'Twasn', 'twer'n, 'twerden**

Now, you are equipped to argue with anybody!

Travelling

When asking the way, it is better to pronounce place names correctly or you will be greeted by mute stares of bucolic incomprehension. Here are a few of the trickier ones:

Standard English	Dorset
Blandford	**Blan'vur**
Chiswell	**Chis'all**
Lytton Cheney	**Chinny**
Poundbury	**Pummery**
Poxwell	**Po'csle** (to rhyme with *foc'sle*)

When asking the whereabouts of an object or place you should be careful to enquire **where it's to**, e.g. **I be goin up Po'csle. Where's it to?** After enquiring about the direction, you say that you are **going on.**

Food

Your first thought on arriving in Dorset will be to get something to eat, and you need to know the names of favourite local dishes. Dorset food is glorious! The great Dorset writer Enid Blyton has celebrated our jam sandwiches and ginger pop, while William Barnes wrote:

If you in Do'set be aroamen,
An' ha business at a farm,
Then woon't ye zee your eale afoamen!
Or your cider down to warm?
Woon't ye have brown bread aput ye,

An' some vinny cheese acut ye?
Butter?—rolls o't!
Cream?—why bowls o't....

But we would not recommend nowadays that you go to a farm demanding bowls of cream and rolls of butter without first sizing up the farmer. You might not get quite the welcome Barnes leads you to expect.

Perhaps instead we might suggest a trip to the village shop or post office, if you can find one. There you may be able to buy Dorset apple cake, or lardy cake, both of which, we have been assured, are practically devoid of calories. You may also find some Dorset knobs, known locally as **Dorknobs** which will offer a merry challenge to your teeth. If you are camping you could try to catch a rabbit and boil it. Dorset people particularly like to gnaw on the **granny bonnet**, as the rib cage is known, which is delicious served up with **doughboys**, as we call our dumplings. And don't forget when on a cliff walk to take a **nosset** or titbit with you, perhaps some **niddlings** or chitterlings, and a slice of **blue vinny** (blue veined) cheese.

A few tips on pronunciation

To get by in Dorset it's not so much *what* you say that is important, as *how* you say it. Here are a few tips:

(a) Try to talk without moving your lips. Keep your mouth slightly open. Any mouth movement should be at the back of the jaws.

(b) The characteristic *urr* sound from the north and west of the county should be produced in the throat, never at the front of the palate (we are not Scots).

(c) Elide the words as much as possible, i.e. slide them together. Do not make a thing of the consonants, slur them, slide them.

as is	**'s**	of	**o'**
as if	**'sif**	of him	**o'n**
of them	**o'm**	would	**'ud**
on top	**a' top**	with him	**wi'en**
of us	**o' us**	a lot of	**s'lod 'er**
give him	**gi'en**	told him	**twold'n**
big one	**big'n**	(note: *m* goes to *n*)	

(d) Consonants:

t should sound like *d*:
so 'better' becomes **bedder**, 'might' becomes **mid**.

f becomes *v*:
so 'find' become **vind**, and 'friend' **vren**.

s often becomes *z*:
Thus 'so' is pronounced **zoo**, and 'some' **zum**.
'What we've a-**zeed** an' done.'

d sometimes replaces *th*,
as in **dread** 'thread', **drush** 'thrush'

v often becomes *b*,
as in **zeb'mty dree** 'seventy three', **'lɛbn** 'eleven'

Added consonants:
w is often inserted before a vowel:
e.g. **hwome** 'home', **bwoy** 'boy', **mwoan** 'moan'

y also is sometimes inserted before a vowel:
e.g. *kyeakeharn* for **keakeharn** 'windpipe' (the modern version is 'cakehole').

Omission of pronouns
Dorset always tends to compress expressions, sometimes by omitting words

A BIT OF A BUMBLE!

altogether. Chief among these are pronouns, which in a given conversation may be considered as understood between the speakers.

Exercise A

| Assertion: | **Were chatty like**. | 'He was a garrulous person.' |
| Negation: | **Werden.** | 'No he was not.' |

Exercise B

| **Der vall to preddy sprack, lik.** | 'He/she has started eating rather quickly'. |
| **Aah. Do lik's viddles.** | 'Yes. He/she likes his (or her) food.' |

Genders

In Dorset, objects usually take the neuter gender. Near the Somerset border, however, one may hear both masculine and feminine constructions for objects or actions, e.g. **Yer, er don' 'alf go don' er** (said of a ball struck hard by Vivian Richards on Taunton Cricket ground), or **Yer, 'e do fair whizzy like!** (said of a rocket in the sky).

Cussing and Abuse

When visiting Dorset you will naturally want to pass for one of the locals and anyway you will not feel at home until you can abuse people. A good way is to use cuss (curse) words. This book is too polite to print some of them but the following selection may meet your needs:

(a) *Expletives*:

While putting up your tent you may hit your finger with the hammer. In such a case you may relieve your feelings by shouting out some such phrase as **shittle-bum-hurdle** (no translation provided).

(b) *Abuse*:

Dorset is rich in abuse words, and many may be preceded by **gurt** or **vooty** ('petty') or another such adjective. You may call a person a

blatherhead	bladderhead or bighead
grockle	a tourist, holiday-maker, second home owner
lazy Laurence or Lawrence	
	The name 'Laurence' usually signifies laziness.
lummick	stupid person

mammet	a scarecrow, a puppet; an ugly person
naichel voowel	natural fool; one who is not merely stupid, but good at it
stunpoll	idiot (literally one whose head is as dense or thick, i.e. stupid, as a stone)
turd	(very rude)
zainy	As in 'thik girt zainy'; the origin is obscure but the meaning is plain enough.
Zam Zaturday	The name Samuel often suggests stupidity.

Constructions

Let us see what we can make of these hints. Here are a few sentences using some of the expressions we have looked at so far. Practise saying them and try to vary them using the tips you have learned already. Then write out your own translations into English (you may need to refer to Chapter 3 for some of the vocabulary used here):

Do bide wi's mother, like.
Werden nooboddy bud wol' chattermag.
'Twere's rottletraps he had up on thik cart.

Getting by

So, just let fly a few of these phrases when you visit the Elm Tree at Langton Herring, the Swan at Upwey, or the Trumpet Major in Dorchester. After ordering your pint of furmity, you might try telling the landlord some rigmarole about how you found a mampus of bwoys throwing popples at a gallybagger, or mention casually that you've left your rottletraps outside in the cart. You will soon know from the expressions on the faces round the bar just how well you got by in Dorset.

Zoolong!

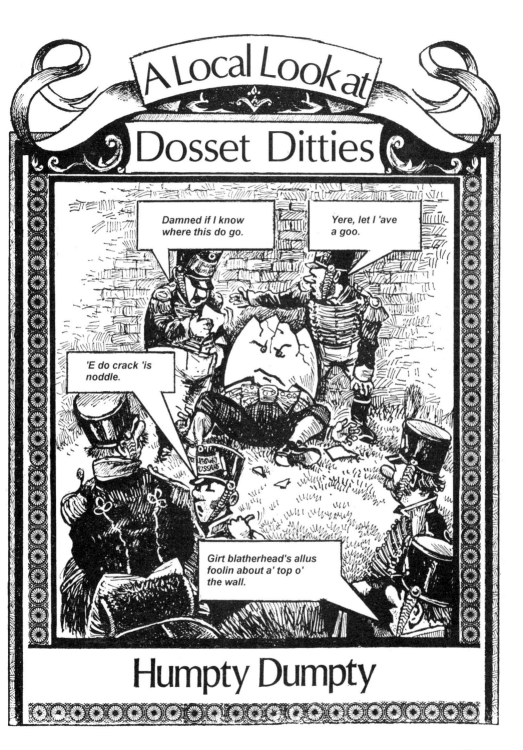

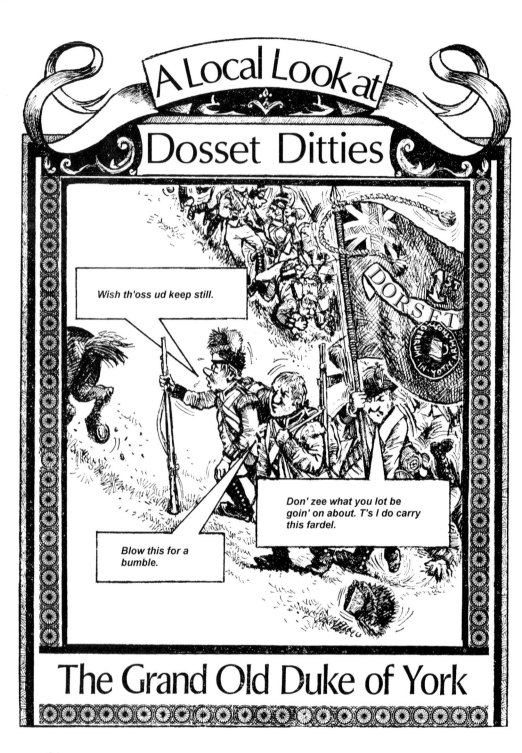

A Local Look at

Dosset Ditties

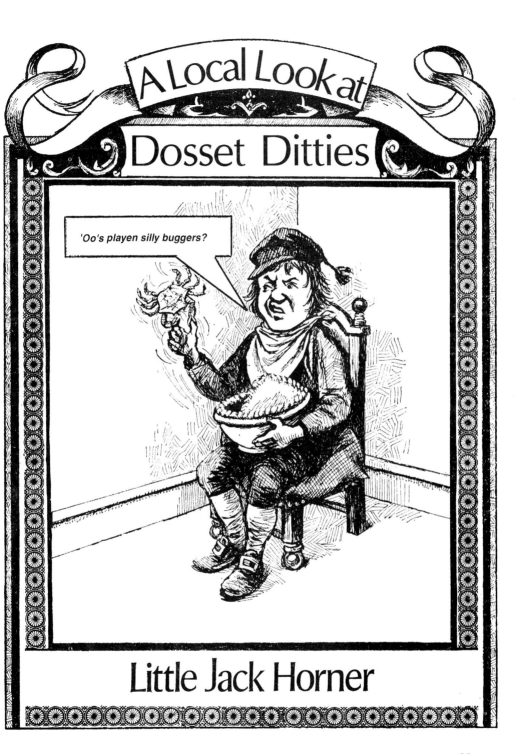

Little Jack Horner

CHAPTER 3

Dictionary of Dorset Words

acker	a mate, pal, friend
aggy	1. edgy, i.e. cornery, with sharp looking joints (WB) 2. to gather birds' eggs.
apiece	for each
ardle	a tangle or muddle
arlus	always
astrout	stretched out stiffly like frozen linen
athirt	across
atter	after
avore	before
avrighted	frightened
ax	to ask
baa	bad
backbron/bron	This was the 'back brand', i.e. the large log placed at the back of the fire. In some places a whole tree-trunk could be fed straight into the rear of the fire, through a hole in the lower part of the chimney or sometimes through the outer door. This obviated the need for tedious wood-cutting in the days before power tools.
beddermos'	bettermost, i.e. socially superior people (R.J. Saville)
betwattled	confused, muddled
bide	to remain or live *I twold'n er bide quiet.*
bigitty/bickety	conceited, i.e. 'too big for his boots'
bigotty slack	A terrible term of abuse. The final insult in an argument before resorting to blows.

blanker/vlanker	a spark or cinder
blue slop	a thin overall jacket
body	woman
Bradbury	a pound note. (I've never heard it applied to the pound coin.)
buoilen'	the lot, the whole set
	I'd hike out the whole buoilen o'm. (WB)
bwoth	both
bwoy	a boy
caddle	a muddle or confusion
cag mag	a person who is a nuisance
car	to carry
carse	course
	A carse e do.
carjun	an accordian, also still known as a squeeze box
catched	caught
chammer	chamber; an old word for bedroom
chattermag	1. a magpie; 2. a women who chatters like one
chimley	a chimney
chiselly	tough, as of meat
chock-vull	full to choking-point
clapsed	clasped
clavy/clavy-tack	a mantleshelf
clear	very or quite close
	How fur did ye goo?
	Clear into town. (WB)
click	a clique, faction
clinker	an icicle
coombe	a small valley (equivalent of Welsh *cwm*)
cowheart	a coward
croop/croopy down	
	bent low down
crope	crept

dawk	to push
diddikie/diddicoy	gypsy (often shortened to diddies in the plural)
'doman	a woman ('old woman')
drash	to thrash
drith	a drout
drong	a narrow way between hedges or walls
drough	through
duckish	twilight
dunch	stupid, deaf
dumpsey	dusk, twilight
fall/vall	autumn
faddle/fardel	a bundle, a load
	(Who would fardels bear?—Hamlet)
fantod	a fuss, a fidget
	She's always in a fantod about Mary. (WB)
	This word crossed the Atlantic and is to be found in *Huckleberry Finn*, 1884.
footy/vooty	small, insignificant
gallied	frightened
gallybagger	a scarecrow
gander	a look
gap	gape
gawk	to gape
	Was gawkin' at?
gay	fresh or green
glim	a feeble light
glutch/glutchy	to swallow greedily
	How 'er do glutch en down!
girt	great (to emphasise big; rarely used nowadays without self parody)
gooner	certainly
granfer	grandfather
hackle	work

handy	useful, near, ready
	For all they lived so handy. (WB)
hanpat	fit and ready
	He had it all hanpat. (WB)
hauck	to cough
het	1. to heat; 2. hot
ho	to care
	I don't know and I don't ho. (WB)
hroun'	round
huckmuck	dirty, slovenly
huzbird	'whore's bird', an abusive expression meaning 'child of a whore'.
	WB says that sometimes angry mothers shout this name at their own children. Presumably they do not know what it really means!
jay	joy
jingled up	muddled up
jonneek	honest, straightforward
jopetty-jopetty	anxious, agitated
	She do go all jopetty-jopetty.
kiddle	a kettle
knap	a hillock
leary/lairy	empty (i.e. hungry); weary
leer or leery	empty
	Thic wagon come back leery.
lew	a lee, a shelter from the wind
limber	very limp, flaccid (WB)
limmer	a painter, an artist (WB)
	[Perhaps from *limer* 'one who puts on limewash'?]
limbless	to bits
	I'll knock thee limbless. (WB)
lippy	wet, rainy
	'Tis lippy weather.

litsome	cheerful
litty	light, cheerful
loie	lie
lop/loppy	to lounge, idle
	Don' loppy about, goo and do some'at.
loplolly	a lazy person
	In his poem 'Toads', Philip Larkin (a Barnes admirer) refers to 'loblolly men'.
maggot	a fancy, whim
maid	a girl, virgin, daughter
main	An emphatic adjective meaning great or mighty.
	'Tis a main girt tree!
mampus	a great number of people, a crowd (WB)
mid	might
moffratite	hermaphrodite
mommet	a scarecrow (perhaps from 'Mahomet')
nesh	tender
noggerhead	a blockhead, a very stupid person
nunch	lunch
oone	one
passon	a parson
pank	to pant
peff	soft, rotten wood
perty	pretty
plain	homely; unaffected
	Lady C. be as plain as a dairymaid.
plim	to swell out or blow up. Yeast makes dough plim up.
ply	to bend
popple	a pebble
posh	1. having money; 2. smart
puggled	stupid
randy	a party

rathe	soon; early
reckoning	wages
rottletraps	odds and ends of household goods
ructions	trouble, rioting
scavenger pit	a rubbish dump
scrammed	twisted, screwed up; *scrammed with cold*
screws	rheumatism
scud	a rain storm
shard	earthenware
shim/skrim shanking	
	doing things without care
slack twisted	untidy or careless
smarm	to soil, dirty
smeech	dust
snoodling	drizzling
so'jer/sojerin'	soldier/soldiering
	He be goin' fer a so'jer. He be goin' so'jerin.
sope-me-bob	An exclamation once very common throughout the West Country, a euphemism for 'So help me God'.
spicketty	speckled
square pushing	courting
squeamish	sickly, nauseous
squinch	a pinch
	Can ye lend me a squinch o'tea? (WB)
squot	flattened, squashed
staff of life	the penis
stooded	stuck
stud	still and wrapped in thought
taffety	choosy
tardle	tangle, entanglement
thouse	without; unless
tiddyvate	to decorate oneself
toot	to cry

torrididdle	bewildered, almost mad
	You'll dreve me torrididdle. (WB)
totties	feet
trig	to prop up or lever
tun	a chimney (an older dialect word than chimley)
twit/twite	to tease or taunt
vlummox	flummox; confusion
	I be all of a vlummox.
volk	folk, people
ware	crockery (see also earthenware)
wi'	with
wink	to wind or winch. The starter handle of a lorry is also called a wink.
wordle	the world
wuss	worse
zennit	seven night, i.e. a week
zummit/zummut	something

WORDS FROM THE FARM

Even as recently as 1922, John Symonds Udal could write that Dorset was a 'largely pastoral county' but at the present time it has been estimated that less than 1% of the county's population is engaged in farming. Inevitably, the dialect words deriving from agriculture have disappeared more quickly than any other kind but here is a record of just a few of them:

a-co(a)thed	rotten, diseased, such as sheep with liver disease, or
	the plaice worm in the stomach. (Old English *coda, code* 'a sickness', 'an ailing')
	The sheep were all a-coath'd. (WB)
archet	an orchard
a-stooded	sunk in the ground.
	The waggon be a-stooded.
a-stogged	having one's feet stuck in mud

a-zew dry of milk; no longer giving suck
 The cow's a-zew.

backhack to break up clods with a mallet

backhouse an outhouse; wood house

bandy a long, heavy stick with a bent end, used to beat dung into
 the fields

bargen a small farm or homestead

barrow pig a hog

barton/barken an enclosed yard for cows (from Old English *bere* 'barley' +
 tun 'enclosure')

batch a small rising in the ground, hill or knap.

baven a bunch of untrimmed twigs for burning.

beas beasts (applied only to cattle)

bee hackle See hackle

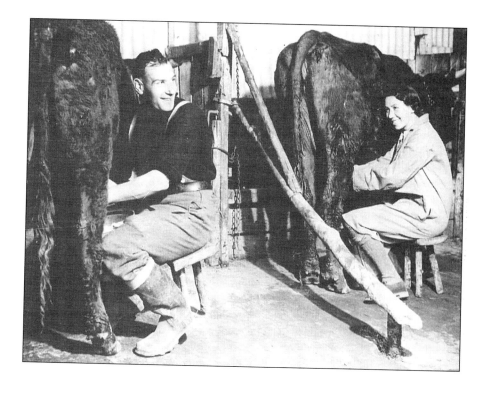

belly	a bundle of thatch
bell-plow	waggon and team of horses with bells
bennets	grass seedheads
blue shag	a type of sheepdog
bird-batten	to catch birds with nets
bird-kippy	to keep birds from corn
blooth	blossom
bolt	to run to seed
breast-plow	tool for cutting turf
bremble/brimble	a bramble
brockle	(of cattle) liable to break out of the field
brushet	brushwood, scrub
bug-a-lug	a scarecrow or gallybagger (a bug or bugbear on a *lug* 'pole'); by extension it could also mean a person who looks a fright
capple cow	a cow with a white muzzle
chilver	a ewe lamb
cider wring	a cider press
clacker	a rattle used to scare away birds
clod'opper	a farm labourer
codgloves	hedgers' gloves, with all the fingers together
colepexy	to glean the few apples left after the tree has been harvested
copsing	the scything of docks and nettles
couchy	to pull out couch grass
cowlease	a lease where cattle are grazed
cow-cap	a metal knob put on a cow's horn
crannick	a root of furze or gorse
creosoling	creosoting
criddle	to curdle
cue	an ox shoe
dewbit	William Barnes reports that agricultural labourers claimed that in the long working hours of summer they needed seven meals to sustain them. These were dewbit, the first bite when

the early dew was still on the ground, breakfast, nuncheon, cruncheon, nammit (cold meat), crammit, and supper.

WB thinks that this list was merely a sort of repetitive jingle and that nuncheon and nammit were probably the same meal. In these long hours of haymaking or harvesting, flagons of beer or cider were often kept cool by lowering them on string into a nearby stream.

dock-spitter — tool for digging out docks

drail of a plough — a toothed iron bar, projecting from the beam of a plough to which horses could be hitched

drashel — 1. a flail

The flail was an instrument for drashing or threshing corn, i.e. beating out and separating the grain from the chaff. It consisted of a wooden staff (the handstaff) with a heavy stick (the vlail or flegel) swinging or 'flying' from one end (Old English *fleogan* 'to fly').

2. a threshold

The two meanings may be connected in that the threshold may have been the place where once the corn was thrashed.

dra'ts — the shafts of a cart

dredgel — a flail (See drashel 1)

drongway/drung — a narrow path between hedges

drove — a way between hedges along which cattle are driven from the fields

('A narrow drove is a drong'. WB)

Up until the 18th century, there were many droves in the West of England, along which cattle were driven to markets in the large towns and cities.

dung-spurring — manure spreading

eacer — an acre

elt — a young sow which has not yet farrowed

ewelease — a lease where sheep are grazed

exe — an axle

faggot — a bundle of sticks for the fire

falter	to fail as a crop
	I be afeared the teaties wull falter. (WB)
flook/fluke	the liver fluke, a parasitic flatworm found in the livers of sheep and other vertebrates
gawl	a bare patch in a field of corn
grip, grippy	to tie up in sheaves
grotten	a run or pasture for sheep
grout	to dig out a small ditch
gudgeon	a short-forked stake used in hedging
gyett/geate	a gate
hackle/bee hackle	a sheaf of straw forming a roof over a bee-hive
halfway hoss	a cross between a Shire horse and a hunter
hain/winterhain	to lay up grassland rather than put stock on it
ham/hamel	an enclosure
hame	either of a pair of curved attachments on a draught horse's collar through which the traces are passed
hangen	the sloping side of a hill
hangen-house	a shed under the roof of a house
haskets	hazel and maple bushes; brushwood
hatch	a wicket or a little low gate; a half door
haymeaken	WB gives an account of the several operations of haymaking:
	1. the mown grass was spread abroad (tedded), and afterwards turned once or twice;
	2. in the evening it was raked up into little ridges, rollers, either by one or two rakers working against each other; sometimes it was put up into small cones called cocks;
	3. the following morning the rollers or cocks were spread around in passels or parcels, and in the evening thrown up into large ridges or weales;
	4. the weales were sometimes pushed up into larger cones called pooks.
hayward	When there was still common land the hayward was responsible for seeing that it was not grazed by the animals of those who had no common rights. Sometimes

he would dreve the common, i.e. get all the livestock into one corner and impound the animals which should not have been there.

headlen/headland the ground or ridge below a hedge, where the horses turn for ploughing

hethcropper 1. a pony bred on heathland; 2. a disparaging name for people from Wareham, which is on the heath.

hoss horse

kecks/kex a stem of hemlock or cow parsley

keech to cut grass and weeds in water

kiyer a gypsy

lark's lease an unfenced field. A cowlease is fenced to keep the cattle in but nothing can restrain the lark so anything unbounded is a lark's lease. WB says that 'the business is all at lark's lease' meaning that it 'is not brought within any lines within which it can be settled'.

leades See reaves

lease/lea a field in which animals are kept during summer as opposed to a mead, which is mown, e.g. ewelease, cowlease, etc.

limbers the shafts of a wagon

linchet a ledge of ground running along the side of a hill. Strip lynchets are of ancient origin and frequently found in Dorset near prehistoric earthworks. Farmers would have to cope with them as they did with the ancient tumuli or burial mounds.

linhay a low-roofed shed attached to a house

lug a pole

mainpin a pin put through the fore-axle of a wagon for it to turn upon locking (WB)

maintainance manure spread on the land

man/maun a large two-handled basket for apples, potatoes, etc. (AS mand)

marten a heifer that does not breed

mead/meade a meadow, grassland, esp. used for hay, as contrasted with a lease, which was used for grazing

A BIT OF A BUMBLE!

meesh	the lair of a hare
mixen/midden	a dungheap
mouel	a field mouse
lance/lanch	sloping gound
naps/knee-naps	protective leathers worn over the knees by thatchers and the like
nesseltripe	the most weakly of a family of animals, such as fowls or pigs, or even children
niggly-van	a homemade wooden trap to catch pheasants
nirrup	a donkey
nitch	a bundle of sticks, hay, wood, straw, etc.
orts	leavings from hay fed to the cows
parrick	a paddock; a small enclosed field
pick	a hayfork or dungfork

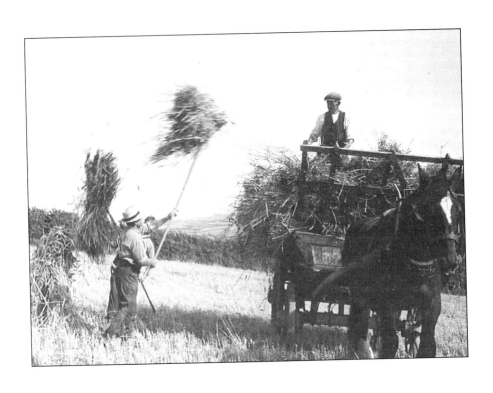

38

pitch	to throw, especially hay onto a waggon
plesh	to cut the large stems in a hedge nearly but not quite off, so that the sap will rise over the cut and more shoots will be thrown out
plough	WB says that in the Vale of Blackmore a waggon is called a plough, whereas what is called a plough in standard English is referred to as a zull.
	In the Monmouth Rebellion of 1685 Colonel Kirk published an order to the parish of Chedzoy: *These are in His Majesties name to require you forthwith, on sight hereof, to press men and plowes.* (i.e. waggons).
to puddle	to place a hand beneath potatoes in the soil to see whether they are ready to be lifted
pummice	the apple pulp left over in a cider-press when the juice has been extracted
reaves/raves	the ladder-like framework on a wagon used to support a bulging load of hay, etc. The reaves (also called leades) are propped up by strouters or stretchers. (WB)
riddle	a coarse sieve
roller	1. a ridge of hay; 2. a roll of wool.
scrip	a hedger or shepherd's coat
scroff	leavings; chips of wood from the cutting
singling	thinning rows of swedes etc. with a hoe
sive	See zive
skent	diarrhoea in cattle; scouring
snead	the shaft of a scythe (zive)
snoff	to pick the heads off small fruit
spud	1. a small spade 2. also spuddle, to dig over lightly or inexpertly (*spudding up docks* Thomas Hardy)
squitters/squits	diarrhoea
staddle	a wooden framework on which a rick is made to prevent it touching the ground
	Some barns are built on staddle stones, either to keep the stores of grain safe from vermin or to keep their contents above the floodline. There is such a barn in the village of Upwey near the River Wey at Weymouth.

steam plough	two engines placed on either side of a field with a plough which was mounted by a man to guide it and was pulled from one engine to the other
	Steam ploughs were in use after the First World War
stickle	a steep roof on a hay rick
stitching	putting hay up into stooks
string horse	the front horse of a pair in tandem
swarmer	a farm dog which roams and causes trouble
tallet	a hay loft over a stable
vurrer	furrow
wimming	winnowing
whicker	the low neighing sound of a horse
wring	a press, as a cider press
yarks/yorks	leather straps buckled below the knee to keep trousers out of the mud
yow	ewe (rhymes with *sew*)
zive/sive	a scythe
zull	a plough

BEASTS, BIRDS , PLANTS AND TREES

Beasts

airmouse	bat (WB)
beast	stock; oxen, etc.
beetlehead	tadpole
black-bob	cockroach.
bullock	A collective term for bull, ox, heifer or cow
creepen junny	woodlouse
curleywig	earwig
dumbledore	bumblebee
emmet	ant
	(The word is sometimes used rather discourteously to refer to holiday-makers.)

emmet but	ant hill
evet	newt
flittermouse	bat (compare German *Fledermaus*)
furret	ferret
God 'lmighty's cow	
	ladybird
hoss-tinger	dragonfly (WB)
	[horse-stinger? AC]
miller/millard	a large white moth (WB)
hoss	horse
palmer	caterpillar
rot	rat
showcrop	shrew, shrew mouse
want/wont	mole
vearies	1. fairies; 2. weasles
welshnut	walnut (WB)
wops/wopsy	wasp

Birds

cutty/cutty wren	wren
devil screecher	swift
Polly wash dish	pied wagtail
reddick/reddock/ruddock	
	robin (WB)
spadger	sparrow

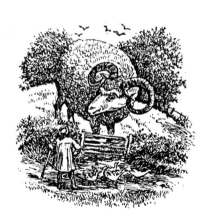

Trees and plants

aish	ash tree (WB)
aller	alder
ash-candles	the seed vessels of the ash (WB)
baub	bulb
bithy-wine	bindweed
bitterzweet	a variety of apple used in cider-making

blooth	blossom
broccolo	cauliflower
charlick	charlock, field mustard
chipple	spring onion
churry	cherry
clote	yellow waterlily, *Nuphar lutea*
conker	the fruit of the horse chestnut
culver	dove
daffidowndilly	daffodil (WB)
dewberry	a large variety of blackberry
eacor	acorn
elem	elm
eltrot	1. cow parsley, *Anthriscus sylvestris*; 2. hogweed, *Heracleum*
gilcup	buttercup
greygle	bluebell (wild hyacinth)
Granfer Griggle	a species of wild orchid
kern	seed (noun or verb)
moot	the stump of a tree
	(*By the oak tree's mossy moot.* WB)
ollerrod	cowslip
pissabed	the dandelion, long thought to be a diuretic (WB)
snag	sloe
tiddies/tayters	potatoes
Tom Pud/Tom Putt	
	a variety of large, streaked eating apple
turmit	turnip
tutty	a nosegay of wild flowers
vuzz/vuzzen	furse, gorse or whin, often dried to light bread ovens, etc.
withywind	convolvulus, bindweed

EVERYDAY WORDS AND DORSET CHATTY

a-	Often placed before a verb as in
	He were a-walken' to town.
aah	yes
a bit of a bumble	a confusion
alass'n	unless
al's	all this, all this day
ammit?	hasn't it?
anby	soon, by-and-by
anywhen	at any time
ar/ara/arn	ever a one, any
arntall	not at all
ass	that's
ass?	have you? (contraction of *hast thou?*)
assn?	haven't you? (contraction of *hast thou not?*)
back along	some time ago
bean't	it isn't (reduced form of *it be not*)
bed'n	(he/she) kept on (doing something)
	Er bed'n comen yer Fridies.
ben'um?	aren't they?
be'uns/ been's	being as, i.e. because
	I can't do it today, been's I must goo to town. (WB)
bide quiet	to be still and silent
bissen	be-est not, art not, be not
bist	be you; you be
by'n-by	soon, later on
can't be doin' wi'	can't be bothered with
	I can't be doin' wi' all thik yer vallen out, like.
ca's	canst
cass'n	cannot, canst not
	Cass'n come da Weymouth?

A BIT OF A BUMBLE!

coussen?	couldn't you? (contraction of could'st not? could you not?)
da	to
daps	a likeness
	He's the very daps of his Dad.
diss?	did you? (contraction of *did'st thou?*)
diss'n?	didn't you? (contraction of *did'st thou not*)
doos't?	does thou? do you?
'ee	ye, thee, you
girt	great, big
gi'us	give me (not give us)
hamchaw	to hem and haw
hassen	hast not? have you not?
hizzulf	himself
homealong	homewards
How do?	How do you do?
if so be	if it is, if it turns out to be
Immabbe	It may be.
in coo'se	of course
issum?	are they?
janoo?	do you know?
lookzee	look and understand
'low	allow, i.e. admit, reckon, or think
	She be main perty, that I'd 'low.
mid	may or might
mwoorish	very good, so that the speaker wants more
	This word has come back into the modern speech of townspeople.
nar	never, never a one of; no
narn	none, not one
near	stingy, miserly
noo-how	in no way or shape
noo-when	never, at no time

o'	of
o/o'en:	of him/her/it
on	Often used to reinforce a verb:
	I be goin' on then. i.e. I shall continue on my journey.
o'm	of them
o's	of us
our	WB says that in Dorset this is often put before the name of a relation as in 'our Mary'.
put-to	in difficulties
	He's a-put-to vor money. (WB)
seem an I	it seems to me
shassen	shall not
shatten	shalt not
should	frequently used to moderate or soften statements and queries:
	e.g. *I should say he were not over sprack* (WB),
	meaning 'He does not work very briskly', although it seems to mean 'I should say (if I were asked) that he's not very brisk'.
	The speaker does not state positively that the man is lazy, which would be rather too pointed for Dorset speech.
's'now	you know (contraction of *thou dost know*)
so's	souls, people. A very old usage, rather like that employed in Russia in Tolstoy's time, where a landowner's wealth was counted in the number of 'souls', i.e. serfs or people, that he owned.
so's	so as
so't	soft
so'st	so as to
	'E be turble near, so'st kip 's money for 'imself.
'st know?	do you know? (contraction of *dost know?*)
thaise/thaize	this, this one
thic/thic there	that
thic there oon	that one

'tidden	it is not
'tissen	it is not
to	often used to reinforce a verb:
	Where be goin' to?
t'other	the other
t'otherm	the others (contraction of *the others of them*)
t'wadden	(it) was not
upzides with	even with, giving tit for tat
vall-in-wi	to meet with, agree with
vall-out-wi	to quarrel, disagree with
vall-to	to set to work, eating, etc.
werden	were not
wadden	was not
wamble	wander
	How that wheel do wamble!
Wher's it to?	Where is it?
would	like 'should', often used as a 'softener'
	I was once asked on the telephone:
	Would that be Mr C? not *Is that Mr C?*, which might have seemed too abrupt. The question seems to imply *Would I be told that this is Mr C if I were impertinent enough to ask?*
wull	will
wust?	would you? (contraction of *wouldst thou?*)
wut?	will you (contraction of *wilt thou*)
yer	1. ear; 2. here; 3. to hear
zid	seed, i.e. saw
	I zid 'en.
zoo	so

CHAPTER 4

The Country Calendar

Older people can remember some Dorset customs which have survived until quite recently from medieval times and which mark days of the year.

1st January: New Year's Day
Should this fall upon a Thursday people believed it would determine the weather for the rest of the year:

> *Winter and summer windie. A rainie harvest. Therefore we shall have overflowings; much fruit; plentie of honey; yet flesh will be deare; cattel in general shall die; great trouble; warres.*

6th January: Twelfth Night
The last day on which to eat mince pies. To eat one on each of the twelve days of Christmas was believed to ensure happiness for the following year, or at least to ensure a month's happiness for each mince pie eaten.

2nd February: Candlemas
From Lyme Regis the following was reported:

> *The wood ashes of the family being sold throughout the year as they were made, the person who purchased them annually sent a present on Candlemas-day of a large candle. When it was lighted, and assisted by its illumination, the inmates regaled themselves with cheering draughts of ale and sippings of punch, or some other animating beverage, until the candle burnt out.*

This was the day when the holly, mistletoe and evergreen decorations from Christmas were to be taken down. They were not to be thrown out but burnt. Failure to do this would bring about death or misfortune to members of the family.

A BIT OF A BUMBLE!

14th February: St Valentine's Day

For many years it was customary for unmarried girls to suspend a nosegay – a true lover's knot – in the kitchen. It was thought unlucky for their marriage prospects if the first visitor to the house on this day were not a man. Here is one custom:

> *Three single young men would go out out together before daylight on St Valentine's Day with a clapnet to catch an old owl and two sparrows in a neighbourhood barn. If they were successful and could bring the birds to the inn without injury before the females of the house had risen they were rewarded by the hostess with three pots of purl [hot ale with bitter herbs] in honour of St Valentine, and enjoyed the privilege of demanding at any house in the neighbourhood a similar boon.*

(The owl was regarded as the symbol of wisdom and the sparrows as lovers benefitting from his advice.)

Shrovetide

The three-days immediately preceding Lent were spent in merrymaking and sports. At the beginning of Lent the populace went to confession and were afterwards shriven, i.e. absolved of their sins.

Shrove Tuesday: pancake day

This day, the start of shrovetide, was celebrated in many places in Dorset, most commonly by the custom of 'Lent crocking'. Children would go round the parish knocking on doors and asking for a little refreshment such as pancakes or bread and cheese. If they were refused and the door closed on them, they would step back and pelt it with broken bits of crockery. Pancakes served to wrap up all the odds and ends of food that should be eaten before Lent; in medieval times the tradition was for no meat to be eaten during Lent so that the cooking vessels would not be needed.

Lent crocking or pansharding was a tradition common throughout Dorset. The children's door-knocking was usually tolerated though they were not supposed to throw stones. Despite this, some of the rhymes or chants have a rather threatening ring:

> *I'm coming ashroveing*
> *For a piece of pancake,*
> *Or a piece of bacon,*

Or a little truckle cheese
Of your own making.
Give me some or give me none,
Or else your door shall have a stone.

In Portland the boys went round the villages throwing stones and chanting

Slit, slat, sling,
If you don't give me a pancake
I'll make your doors ring.

In Cerne Abbas, at one time, boys were allowed to hurl logs of wood against the school door, which was stout enough to withstand the onslaught. The end result was merely that the schoolmaster collected a pile of firewood.

The need for Lent crocking to be kept within control was demonstrated by Bridport magistrates in the 1880s, who fined two young women six shillings with eight shillings damages for throwing a large stone jar at the front door of an elderly widow.

When I appeared on a West Country TV children's programme, I was asked not to explain pansharding to the audience because the police feared it might encourage vandalism.

In more brutal times a bird was tethered to a stake and the village boys would throw stones to kill it, a practice known as **cock-squailing**.

Mid Lent: Mothering Sunday

Before the Reformation it was customary on this day for people to visit their mother church to make offerings at the high altar. Grown-up children would sometimes visit their parents to eat furmity with them. This was a dish of mixed spices and currants or raisins (Latin: *frumentum*) boiled together with wheat and milk.

Thomas Hardy refers to furmity as 'antiquated slop' in *The Mayor of Casterbridge*.

Good Friday

Bread baked on Good Friday was supposed never to go mouldy. It was also used as a talisman for preventing later bakings from deteriorating. The late Rev. Canon C.W. Bingham, a well-known writer on Dorset antiquities, wrote

Good Friday is one of the most important days of the year... Many of the villagers still make a point of baking a batch of bread on that day, and of setting apart a miniature loaf to be carefully kept, hung up by the fireside, throughout the year. It will prevent the bread of other bakings from turning 'vinny' [mouldy] or sour. A few crumbs of it, soaked in milk, are a sovereign specific for most of the ailments to which children's flesh is heir to.

In like manner they sow gilly flower seed at precisely 12 o'clock on Good Friday, in the belief that the flowers will come up double. Potatoes 'set' on that day ... will have an important influence on other 'settings' of the season.

A cross marked on the dough before baking was supposed to ward off evil spirits and thus prevent mould, hence hot-cross buns. Cakes marked with crosses were fed to cattle to cure disease. On the other hand, there were certain prohibitions associated with the day: on Portland it was believed that cutting finger nails on Good Friday would result in toothache for the rest of the year. Soapy water was not to be thrown away or it would turn to blood.

A weather rhyme goes

Rain good Friday or Easter Day,
Much good grass, but little good hay.

Easter Monday: Hocktide
On the Monday or Tuesday after Easter, lenten sobriety was cast off in favour of simple games such as **hocking**. On the Monday men of the village would bar the way of the women with ropes and 'pull the passengers to them desiring something to be laid out in pious uses in order to obtain their freedom'. Which all sounds like an excuse for larking about. On the Tuesday the men and women reversed roles.

Ascension Day
In many parts of Dorset it has been the custom for the dignitaries of the parish to **beat the bounds**, i.e. walk round its limits, in order to proclaim and maintain its ancient boundaries. A number of village boys were frequently taken along as witnesses to the future, and they were helped to remember the boundary lines by providing them with an effective aide-memoire. If the boundary were a stream, the boys may have been tossed into it; if a ditch they might be bribed to jump over it; if a hedge, a stick might have been cut and the boys beaten with it; if a sunny bank they might be treated to bread and cheese and beer while sitting on

it. Years later, the grown men might remember the boundary line by these tokens and exclaim: 'Ees, that 'tis, I'm sure o't, by the same token that I were tossed into't, and paddled about there lik a water-rot till I were hafe dead!' or 'O ess it be, that's where we squat down and tucked into skinvull of vittles and drink'. (WB)

Such an occasion took place on Portland on Ascension Day (May 4th) 1967 when the boundary of the Royal Manor with Abbotsbury was solemnly marked by a procession of the Court Leet to the 'bound stone'. The ceremony was attended by members of the Urban District Council, the Flag Officer Commanding the naval base, and representatives of local churches, banks, schools and other establishments. After the colours had been hoisted and the boundary checked, two local boys, Colin Peters and Dana Milverton, were required to lay themselves on the stone when 'strokes were applied to their persons' with the reeve staff by the rector, who afterwards concluded the proceedings with a short service.

1st May: May Day

As in many other counties, dancing round the maypole was a common custom on May Day until prohibited by the Long Parliament in 1644. However, some vestiges of the custom were still to be found in Dorset long after. The most 'pagan' of these were probably the celebrations held in Cerne Abbas, where the chalk figure of a priapic giant towers over the village on Trendle Hill.

In his *Anatomie of Abuses* (1583) Philip Stubbes wrote:

> ... hundreds of men, women and children go off to the woods and groves and spend all night in pastimes, and in the morning they would return with birche boughs and branches of trees to deck their assemblies withal. And they bring home with great veneration the Mai-pole, their stinking idol rather, covered all over with flowers and herbes, and then fall they to leaping and dancing about it, as the heathen people did. I have heard it crediblie reported by men of great gravity that, of an hundred maides going to the wood, there have scarcely the third part of them returned home again as they went.

More innocent May Day celebrations were recorded by Willam Barnes who recounts how Dorchester people would go out into the 'flowerey airy sward' of Poundbury field to drink syllabub of fresh milk. In Bridport, children carrying flowers would march in procession to St Mary's church for a service.

13th of May: Garland Day

In Abbotsbury, the children of the fishermen would build up large garlands upon frames, and carry them from house to house, begging small sums from the householders. Later in the day, the garlands were put into the boats and taken out and thrown into the sea.

Mid-June

High on a hill above the village of Abbotsbury stands the ruined Norman chapel of St Catherine. In the south doorway there are 'wishing holes' for hands and knees. Here on June nights, maids (unmarried girls) of the village would go and pray to the saint:

> A husband, St Catherine,
> A handsome one, St Catherine,
> A rich one, St Catherine,
> A nice one, St Catherine,
> And soon, St Catherine.

23rd of June: Midsummer Eve

On this night, each unmarried girl was wont to walk through the garden with a rake over her left shoulder; throwing hemp-seed over her right shoulder, she would repeat

> Hemp-seed I set, hemp-seed I sow,
> The man that is my true-love come after me and mow.

The future husband was then supposed to appear, coming after her with a scythe in his hand. (See Thomas Hardy: *The Woodlanders*, ch. 20.) A girl might also place her shoes at right angles to each other before getting into bed, saying

> I place my shoes in the form of a T,
> Hoping this night my true love to see,
> In his apparel and in his array,
> As he goes forth on every day.

Another way for a girl to get a glimpse of her future husband was to put out bread and cheese and cider on Midsummer Eve and wait until the clock struck twelve, when the spirit of the man would come and take some refreshment. (See Thomas Hardy: *Under the Greenwood Tree*, pt. I, ch. 8.)

Less cheerful was the belief that if one sat in the church porch on Midsummer Eve, one would see those who were to die during the following year go into the church but not come out again.

31st October: Hallowe'en (All Hallows' Eve)
Many children nowadays put candles in pumpkins and play out the American ritual of 'trick or treat'.

5th November: Guy Fawkes Night
On Portland, the custom was for each man to pick up a child and then to leap over the bonfire with it. Later the children would sing

> *Wood and straw do burn likewise,*
> *Take care the blankers don't dout your eyes.*

24th December: Christmas Eve
The 'backbron' or large log would be brought into the kitchen and the farm labourers would sit round and drink beer or cider. There was a popular notion that no evil could be done on this night and that the cock would crow all night long. (See *Hamlet*, Act I. Sc. 1) No-one was supposed to eat a mince pie before Christmas Eve or after Twelfth Night.

Next Nevers-Tide
Frequently referred to in the dialect, this was the feast day which never came. That is, it was a popular expression meaning 'never'.

CHAPTER 5

Old Dorset Customs

Sheep-shearing

In Dorset sheep-shearing was usually finished by the end of May, which is rather earlier than in more northern counties. In previous times the farmers with their shepherds and labourers would all combine to do the job but in later years companies of paid workmen were employed. At the end of the shearing a substantial supper was provided for the entire workforce consisting of a 'hot meat, vegetables and plum pudding, and in some places an extra roly-poly gooseberry pudding', which was spread out on a sheet in the barn or on the turf outside.

Describing a sheep-shearing in *Far From the Madding Crowd*, Thomas Hardy wrote:

> *The large side doors were thrown open towards the sun to admit a beautiful light to the immediate spot of the shearers' operations, which was the wood threshing-floor in the centre, formed of thick oak, black with age, and polished by the beating of flails for many generations, till it had grown as slippery and as rich in hue as the state-room of an Elizabethan mansion.*

And William Barnes wrote:

> *An' when the shearen time do come*
> *Then we do work from dawn to dark;*
> *Where zome do shear the sheep, and zome*
> *Do mark their zides wi' measter's mark.*
>
> *An' when the shearen's all a-done*
> *Then we do eat, an drink, an zing*
> *In measter's kitchen till the tun*
> *Wi' merry sounds do sheake an' ring.*

Whitsuntide and club walking

With the coming of Whitsun it was the custom in many areas of Dorset for the local 'club' to process through the village. Before the coming of the welfare state, these clubs offered the poor some small measure of protection against unemployment, sickness and funeral expenses. In the mid 19th century, the rules required that members should each pay 2s 6d to the family of a member who had died, or 1s on the death of his wife.

Though the club walking might take place earlier in May, it was usually at Whitsun. Members wearing rosettes and sashes, and carrying flags and banners, would be preceded by a band round the village.

The custom was to march in fours; the outer man of each four was generally older and carried one of the club poles. These were elaborately decorated, painted blue or white, with round knobs often painted yellow.

The club would call at the principal houses where members were likely to be given refreshment (sometimes in the form of jugs of cider) or even money. Though the marches must have become increasingly merry, it was usual for the members to present themselves sufficiently sober for a service in the parish church at noon. Afterwards a 'feast' was held in a marquee on the land of one of the farmers, though the dinner was usually paid for by the club. The event was often attended by members of the local gentry.

Afterwards there were country sports, games, and dancing for the younger ones. Sometimes there was a small fair with stalls for sweets and cakes, and perhaps a shooting gallery, Aunt Sally or other amusement.

Haymaking

The different processes of haymaking are described in **On the Farm**. Before industrialisation, every spare hand was needed both for haymaking and later to get in the harvest. At such times the fields were full of people, whereas nowadays the work can often be done by just one man and a machine. Even the children were taken out of their board schools to help as best they could in the backbreaking work, which lasted through the long summer day. The women and younger children would carry out food and drink to the haymakers. Beer or cider might be kept cool by lowering the jars into a local stream. Men wore caps and were usually entirely covered except for the lower arms but more than one incident was recorded of a small child, given perhaps an unaccustomed 'wet' of cider, who fell asleep among the haycocks and died of sunstroke.

Harvest home

The biggest event of the farming year came with the getting in of the corn

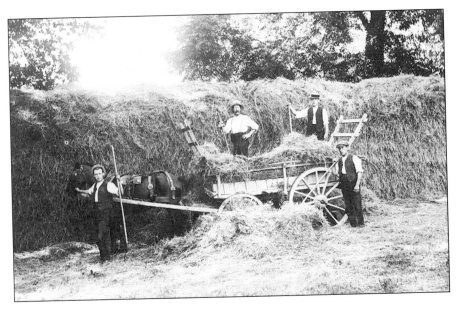

harvest. It was the custom for many years to mark this season with a harvest home, at which the farmer would entertain his workers to a feast, sometimes preceded by afternoon service at the parish church. On this day the entrances to farms were often decorated with archways of flowers, corn, etc. or other decorations made from wheat or barley sheaves. When the company was gathered together it was treated to a dinner of beef, plum pudding, ale and cider, presided over by the 'master' and his family, and attended by every worker who had helped to gather in the harvest.

John Symons Udal reported one such harvest home in west Dorset where after the dinner the whole company adjourned to a large tree where the men would form a circle and stoop to the ground. The head man in the centre would then announce 'We have 'en' (i.e. 'We have it— the harvest— safely in.') three times, and the men, gradually rising, would join in and give a final shout of 'Huzza'. The women would repeat the ceremony. Afterwards the company would return to the house for more drinking, singing and dancing.

Christmastime

This season would be marked by 'going a-Christmasing', in which poorer people from the parish would trail round the houses of their better off neighbours on St Thomas's Day (21st December) in the hopes they would be offered

something good to eat. The 'twelve days of Christmas' ending in Twelfth Night were also accompanied by carols and church music, the bringing in of the yule log or **bron** and game-playing such as forfeits.

Mummers' plays were a familiar amusement. These were usually presented by young men from the surrounding villages going round with their traditional entertainment. The action usually featured a contest between St George and the Turkish knight, which seems to have derived from stories of the crusades. Sometimes the cast of characters was changed a little; the Turkish knight might be replaced by the king of Egypt for example, but the play nearly always depicted a conflict between Christian and Muslim representatives. Occasionally contemporary figures such as Lord Nelson might appear. Hardy described such an entertainment in *The Return of the Native*. At the conclusion of the piece the players would be offered beer or cider and then they would go on to the next house.

Skimmety rides

This custom could take place at any time in the year, whenever occasion arose as a result of sexual misconduct, usually adultery. Examples quoted by Roberts in his *History of Lyme Regis*, describe how, with the coming of darkness, two performers would emerge from side streets – sometimes in a cart, sometimes on a donkey – one impersonating the wife and another the husband. This was accompanied by laughter and raucous cheering from an assembled crowd, who were well aware of the identity of the couple and their goings-on. The skimmety husband and wife would then start to whack each other with sticks and shout abuse at each other but never use the actual names of their victims. The procession moved slowly through the streets, at last arriving at the door of the unfortunate pair, where the show stayed on for some minutes. The skimmety riders would be followed by local youths armed with besoms, energetically pretending to sweep the doorstep of the couple, as well as other doorsteps throughout the town where it was thought a warning was needed. The performers then collected money from the laughing crowd.

There were variations. At Whitchurch Canonicorum in 1884, accompanied by a beating on tin trays, three grotesque figures were carried in procession around the village and adjacent parishes. One was a male and two were female, and all had been modelled on local people. After the procession, over two hundred spectators in a nearby field watched while the effigies were hanged on a gallows, soaked with paraffin oil and burned. At this point a fight broke out and there were some black eyes and bloody noses in the village the following day.

CHAPTER 6

Ghosts, Monsters and Myths

The Sturminster crash

In 1965 there was an accident on the bridge at Sturminster Newton, when a heavy lorry crashed into a mini and the car's three occupants were killed. Sometime later, a lad was riding across the bridge on his motorcycle, when three figures abruptly stepped out in front of him so that he could not avoid them. To his amazement he drove right through them and when he looked back they were gone.

The Sturminster ghost

Another story from this town concerned a house that was destroyed by fire in 1729. It had been haunted by the ghost of a woman who returned every year to plague her husband on their wedding anniversary by walking through the building with a lighted candle which she put down outside the door of their bedroom. The day the house burned down was that of their wedding anniversary. The man died, but not as a result of the fire. On the contrary, in the smoking ruin he was discovered lying in bed without a burn on him. Outside the bedroom door the candle was found burning. What is more, it would not go out until the man had been safely buried beside his wife.

Boney

During the Napoleonic wars, mothers would threaten their naughty children that the dreadful monster, Boney, (Napoleon Bonaparte) would get them. He was said to live upon human flesh and ate 'rashers o' baby every morning for breakfast'. (Thomas Hardy)

The Dorset Ooser

We know that the ancient practice of wearing masks fashioned to look like animal heads has survived in Dorset until comparatively recent times because some examples have been found. The Ooser mask has grim jaws and is worn with

a cowskin to frighten people. William Barnes says that the word derives from *Wurse*, which was a name for the Devil.

In 1891 the Rev. Canon Mayo wrote:

> The object itself is a wooden mask, of large size, with features grotesquely human, long flowing locks of hair on either side of the head, a beard, and a pair of bullock's horns, projecting right and left of the forehead. The mask or Ooser is cut from a solid block, excepting the lower jaw, which is moveable, and connected with the upper by a pair of leathern hinges. A string attached to this moveable jaw, passes through a hole in the upper jaw, and is then allowed to fall into the cavity. The Ooser is so formed that a man's head my be placed in it, and thus carry or support it while it is in motion. No provision, however, is made for his seeing through the eyes of the mask, which are not pierced. By pulling the string the lower jaw is drawn up and closed against the upper, and when the string is slackened it descends.

An example can be seen in the Dorset County Museum.

The Portland Roy dog

In her book Dorset Folklore, Maureen Hymas recounts the tales concerning this beast: 'The Roy Dog of Portland bars your way and runs all over the Island. He is especially active in stormy weather and legend has it that you have to stand out of his reach or he will drag you under the water. He is said to haunt the Cave Hole near Portland Bill.'

Nanny Diement

This is another Portland story. At one time in Southwell there was a huge rock which was a relic of old quarrying activity. On one side of the rock was a hole big enough for a child to crawl through. The further you went into the hole the bigger it got, and it was rumoured to be the home of Nanny Diement, an evil witch. Portland children who were naughty were told by their mothers that 'Nanny Diement will have you'. The rock has since been destroyed by more quarrying.

The Bryanston dogs

It is said that when not observed, the carved dogs at Bryanston House, by the bridge at Blandford, climb down from their plinths to drink from the River Stour.

The black witch of Spettisbury

(See Willam Barnes's poem 'A Witch'.) Kingsley Palmer quotes:

> There was a woman who lived in the village, and all the farmers believed
> that she was a witch. To keep in her favour they supplied her with eggs
> and cheese, and other farm produce. Her powers were that she could
> stop animals like sheep and cows from passing her doorway. She was
> able to stop them dead with a fixed stare. She would sit in her front room
> all day long and watch people go by.

The Cerne Abbas giant

This figure of a man, displaying a large erection and wielding a great club, is carved into the chalk of Trendle Hill and stands guard over the village. Its age and origins are disputed. The county historian, Hutchins, reports several myths concerning its origin.

One version said that the figure commemorated the destruction of a giant who had killed and eaten a number of sheep in the Vale of Blackmore and had then lain down on the hill to sleep. While he lay there a number of enraged farmers crept up and killed him. His outline is left on the hill. Some said it was the figure of Hercules 'the Phoenician leader' of their first colony in Britain, come to trade for Cornish tin.

The giant was thought to have procreative powers, and to be a cure for barren women if they sat on it all night. An alternative version held that to ensure fertility the man and woman needed to have sexual intercourse while lying on the figure. In later times the landowner chose to enclose the figure claiming that he did so because he wanted to prevent immoral activities taking place on it.

Cerne Abbas

Another local tradition maintained that St Augustine and his party visited the village in his mission to convert all England to Christianity. Arriving at Cerne he destroyed the idol Heil, to the dismay of its many worshippers there. He also struck the ground with his staff and brought forth a 'crystal fountain'. But the worshippers of Heil were bent on revenge and, when the saint was sleeping, tied cow tails to his clothes and those of his followers. In punishment, the people of Cerne were cursed so that those who ridiculed the saint in this way, as well as all their descendants, grew tails.

Bincombe 'bumps'

Standing above Weymouth is Bincombe Down with a number of ancient tumuli that stand out plainly against the skyline. Local people used to claim that one tumulus is a music barrow and that, if an ear is put to it at midday, a sweet melody can be heard coming from within.

The Blackdown dolmen

A large dolmen or flat stone was known as the Hell-stone because people thought that the Devil had chucked it across from Portland, nine miles away.

The black dog of Lyme Regis

This story tells of events at a local farmhouse which had once been part of an old manor. In the sitting room was a large fireplace with an ingle nook on either side. In one of these the farmer used to sit in the evenings and he was always joined by a large black dog in the other. The farmer tolerated this and regarded the animal as quite one of the family though the dog cast a gloom around him. On hearing of this, a neighbour advised the farmer to get rid of the dog, but he preferred to leave things be. One night, however, having been drinking heavily and having endured the jokes of his neighbour, the farmer returned home and on seeing the dog, picked up a poker and rushed towards it intending to kill it. The dog, seeing the look on his face, ran upstairs and the farmer ran after. At last the animal was cornered in an upstairs bedroom but, just as the farmer was about to hit him, the animal leaped up and passed through the ceiling. Too late, the farmer struck the very place where the dog had passed through and at once a small box fell down from it. It contained a horde of gold and silver coins. As for the dog, it never appeared in the farmhouse again but was said to haunt one of the local lanes.

Winterborne Abbas

Winterbourns are dry stream beds in the summer that flow only with the coming of winter rains. But according to the late J.H. Moule they can never be seen to 'break' out. He wrote that at one time at Winterborne Abbas a watch was kept on the ditch in autumn to observe the precise moment when the stream should arrive. But one night the watchman found that his pipe had gone out and, thinking that three minutes couldn't make much difference, went up to the nearby Bridehead Lodge for a light. When he got back he found that the winterbourn had 'broken'.

CHAPTER 7

Yarns and Ditties

Extracts from the novels of Thomas Hardy

Thomas Hardy (1840-1928) did not employ a broad Dorset dialect in his novels of Wessex life, probably because he felt that his urban readers would not have understood it. Even so, often his characters speak a modified dialect which retains many of the speech rhythms and phrases of the country people among whom he grew up.

In **The Woodlanders**, published in 1887, Hardy tells the tale of Giles Winterborne, a hurdle-maker, who wants to marry Grace Melbury. Her parents, however, think Giles is not genteel enough for her, and to impress them he invites them all to supper. But the evening goes badly, and afterwards, Giles's serving man, Robert Creedle, reveals just how disastrous the whole evening has been:

> 'Do you think it went off well, Creedle?' he [Giles] asked.
> 'The victuals did; that I know. And the drink did; that I steadfastly believe from the holler sound of the barrels. Good honest drink 'twere, the headiest drink I ever brewed; and the best wine that berries could rise to; and the briskest Horner-and-Cleeves cider ever wrung down, leaving out the spice and sperrits I put into it, while the egg flip would ha'passed through muslin, so little criddled 'twere...Still I don't deny I'm afeard some things didn't go well with He and his.' Creedle nodded in a direction which signified where the Melburys lived.
> 'I'm afraid, too, that it was a failure there.'
> 'If so it were doomed to be so. Not but what that slug might as well have come upon anybody else's plate but hers.'
> 'What slug?'
> 'Well, maister, there was a little small one upon the edge of her plate when I brought it out, and so it must have been in her few leaves of winter green.'
> 'How the deuce did a slug get there?'

'That I don't know no more than the dead; but there my gentleman was.'

'But, Robert, of all places, that was where he shouldn't have been!'

'Well, 'twas his native home, come to that; and where else could we expect him to be? I don't care who the man is, slugs and caterpillars always will lurk in close to the stump of cabbages in that tantalizing way.'

'He wasn't alive, I suppose?' said Giles, with a shudder on Grace's account.

'O no. He was well boiled. I warrant him well boiled. God forbid that a live slug should be seed on any plate of victuals served by Robert Creedle...But Lord, there; I don't mind 'em myself–them green ones; For they were born on cabbage, and they've lived on cabbage, so they must be made of cabbage.'

Hardy's Cottage

In this extract, taken from **Far from the Madding Crowd** (1874), Jan Coggan, a farmhand, is telling some of his fellow workers about the late Farmer Everdene, who was very generous with his ale.

'I used to go to his house a-courting my first wife, Charlotte, who was his dairymaid. Well, a very good-hearted man were Farmer Everdene, and I being a respectable young fellow was allowed to call and see her and drink as much ale as I liked, but not to carry away any – outside my skin I mane, of course.'

'Ay, ay, Jan Coggan; we know yer maning.'

'And so you see 'twas beautiful ale, and I wished to value his kindness as much as I could, and not to be so ill-mannered as to drink only a thimbleful, which would have been insulting the man's generosity.'

'True, Master Coggan, ''twould so,' corroborated Mark Clark.

'And so I used to eat a lot of salt fish afore going, and then by the time I got there I were as dry as a lime-basket – so thorough dry that the ale would slip down – ah, 'twould slip down sweet! Happy times! Such lovely drunks as I used to have at that house! You can mind, Jacob? You used to go wi' me sometimes.'

'I can I can,' said Jacob. 'That one, too, that we had at Buck's Head on a White Monday was pretty tipple.'

''Twas. But for a wet of the better class, that brought you no nearer to the horned man [the Devil] than you were afore you begun, there was none like those in Farmer Everdene's kitchen. Not a single damn allowed; no, not a bare poor one, even at the most cheerful moment when all were blindest, though the good old word of sin thrown in here and there at such times is a great relief to a merry soul.'

'True,' said the maltster. 'Nater requires her swearing at the regular times, or she's not herself; and unholy exclamations is a necessity of life.'

In her book **Dorset's Western Vale**, Sylvia Creed reprints a story as originally told by George Diment of the Marshwood Vale in the west of the county. Two boys start a competition as to who can tell the biggest lie. In the end, the winner comes as a surprise.

This be a story I ganna tell 'ee bout what 'append to oi when oi was a boi. Wun daay oi and my maet was playin outsoid the vicurage gaarden and as we were playin theur we found a woo tin kiddle in the vicurage gaarden 'edge. Moy maet looked at oi and said, 'Oi gonna 'ave 'ee.' Oi zed, 'Noo you baint; oi zid en fust, oi goina 'ave 'en.' Zoo he said 'Alright then, oi'll tell ee what we'll do. The wun oo tell the biggust loies can 'ave the kiddle.' Zoo we started tellun loies, sum vury baa wuns, when ahl uf a suddun the vicur looked uver 'is gaarden 'edge an e looked at us an ee zed, 'You nawghty young rasculs.' 'Janoo,' ee zed, 'tis vury wickid to tell loies loike you've bin doin. Janoo oi nevur told a loi in moy loife.' Moy maet looked at oi and zed, 'Gee un the kiddle, Garge. 'Ee've wun.'

Translation:

This is a story that I am going to tell you about what happened to me when I was a boy. One day, my friend and I were playing outside the vicarage garden, and as we were playing there we found an old tin kettle in the vicarage garden. My friend looked at me and said, 'I am going to have that.' I said, 'No you are not; I saw it first and I am going to have it.' So he said, 'Alright then, I'll tell you what we will do. The one who can tell the biggest lies can have the kettle.' So we started telling lies, some of them very bad ones, when all of a sudden the vicar looked over his garden hedge and he looked at us and said 'You naughty young rascals.' 'Do you know,' he said, 'it is very wicked to tell lies as you have been doing? Do you know that I have never told a lie in my life?' My friend looked at me and said 'Give him the kettle, George. He's won.'

A Remarkable Insect

The old dialect speakers loved a tall story, which they would repeat over and over again. 'Farmer Wangle's Field Talk', from John Read's **Wold Ways A-gwain** (1914), accounts for the name given to the people of Shapwick near Wimborne in east Dorset:

> One day, long years agone, a Shapwick man wur walking along near the village, when all of a sudden he beheld on the ground a most uncommon and curious inseck. Red in colour, he wur, and zummet like a girt overgrowed spider. T'other[1] walked round and round en, afeared to touch en, to be sure; but law, 'twur beyond his skill to put a name to en or to say how he came there. Presently, up comes two or dree more o' Shapwick; but they wur just o' the same way o' thinking as he. So they pondered what they should do. Now in thik village at that time there wur a terrible old-ancient man; a most venerable inhabitant. Coulden walk, coulden talk, coulden do anything thouse empt his cider-cup[2] and smoke a pipe o'baccy just to pass the time away. Folk did come to look at en from miles around, and he wur commonly thought a marvel and a credit to Shapwick. So what did t'otherm do but fetch he up in a wheelbarrow to have a look at thik remarkable inseck and bring his wit to bear upon en! When the wold man eyed en he oped his eyes wide, let fall his pipe, and hollied[3]: 'Here wheel I off, my sonnies, wheel I off!' On the way back they fell in with a fisherman looking for a crab that had dropped from his cart! That's why to this day Shapwick folk be called 'Shapwick Wheel-offs'.

Notes:
1. **t'other** 'the other one', i.e. the man, not the insect.
2. 'unless it were to empty his cider-cup...'
3 **hollied**: 'hollered'

Where Zo Many Volk Be Wrong

The coming of village schools in Dorset towards the end of the 19th century and their emphasis on standard English was one of the forces that worked to undermine the dialect. It provoked a certain degree of resentment. Country people were not always pleased to have their children coming home from school and reckoning to know more than their parents ever did. These children needed to be taught a lesson, that the countryman's commonsense was often of more value than the theoretical knowledge they were offered in school.

Oone day wold Jim's bwoy come out into ploughgroun' wi' wold Jim's bit o' nunch. As wold Jim wur a-zot there hetten it, young Jim zed to en all of a hop:

'Feyther, 'st thee know as how the wordle's hroun! A is, 'st know, cause teacher zed zoo.'

'Huh!' zed wold Jim. 'Mwore fool thee to teake it in. 'St zee thik vurrer?'

'Eees, gooner.'

'Is ur straight?'

'Straight as a gun-barrel!'

'Wull then, young en,' zed wold Jim, hreachen auver vur the cider jar, 'ef the wordle's hroun how can I turn a straight vurrer on en, heh?'

'I don't know,' zed young Jim.

Mwore don't noobeddy.

Translation

One day, old Jim's son came out into the ploughground [bringing] old Jim's bit of lunch. As old Jim sat there tucking into it, young Jim said to him excitedly:

'Father, do you know that the world is round? It is you know, because teacher said so.'

'Huh!' said old Jim. 'The more fool you for believing it. Do you see that furrow?'

'Yes, certainly.'

'Is it straight?'

'Straight as a gun-barrel.'

'Well then, youngster,' said old Jim, reaching over for the cider jar, 'if the world's round, how can I cut a straight furrow on it, eh?'

'I don't know,' said young Jim.

Neither does anybody else.

Learning to Smoke

In 1949, the Swedish linguist Bertil Widen was studying the Dorset dialect and collected many examples round the county. This one, included in Bertil Widen's *Studies on the Dorset Dialect* (1949), was received in the form of a letter from north Dorset.

Deer Bert Wyden. You zaid youd like i to rite a bit ef a yarn. Well yer tis.
When i was a lidde bwoy about haight yers would Father id binbad an he wis gettin a bit beddir. Sue[1] he wis out in garden havin a bit of baccy. and i wanted for un to let I have a draw. Su he villed up another pipe vor me. and liteed en vor me. You shid seed me struttin about like Lord Bug in a wilbar[2]. Well that was alrite. Then Mother cum out a our vront door, an she seemed struck. She says Goo Lor Bill whatever be e doin lettin thick Bwoy ave a pipe like that. Sposen Pason Binghan wis da[3] come on and see en whatefer would er say. Ough Father zaid that ount hurt en[4].
Sue I kep puffin away at theyse yer pipe. Then all at wunce I begun ta veel terible komikal, sue i pud away the pipe, an shabbed[5] of out roun behind our house. I went out in the ground there an led down, and i had da katch hold the gras we bwuth hands an hold on. And the groun wis gwine roun and roun and roun and roun. I did veel quare i can tell e. but it stopped i vrom smokin vor a long time.
Well when I were 21 yers ould I vel in love we a young ooman. She lived out tother side a Blanverd. Her Chrischin name were Sal. an that wer ten mile vrom yer. Sue i only ust to gu and see her Sundays, an comin back at nite zeemed terble lonely. Sue, i thoght i d try a bit a baccy agin, zort a ver company. Sue i got a pipe an bouad $\frac{1}{2}$ hounce baccy and that s how i gradgely got to be a rael Smoker. An now I be semtydree yer ould. an bin smokin hever since. Sue i shid think i mist have smoked pertyneer a Tun.
This is vrom a country feller neer Blandverd Dosset.

Notes:
1. **sue** 'so'
2. **Lord Bug**: perhaps derived from **bug** 'monster', 'bogy', 'bugbear', a scarecrow or sort of hobgoblin, (compare Welsh *bwg* 'ghost'). He may mean that he felt as grand as a scarecrow looks when being pushed in a wheelbarrow.
3. **wis da** 'was to'
4. **Ough Father zaid that ount hurt en**. 'Our Father said that won't hurt him.'
5. **shabbed** 'skulked'.

'Skylark' Durston, the Portland Poet

Cecil A. Durston (1910–1996) was apprenticed as a mason on the island of Portland when the stone industry there employed hundreds of men. He could recall that the masons' 'big shed' was filled with 'tankers', i.e. benches on which the pieces of stone were being worked, while the air was full of the sound of chisels and communal singing. When the young apprentice joined in the choruses for the first time, someone said 'We've got a bloody little skylark yer', and the name stuck.

The Coming of the Masons

In the census of 1851 there are 480 quarrymen listed but only 30 masons. Since Roman times, stone had been quarried on the island and it had grown enormously in fame since Sir Christopher Wren had used it for St Paul's Cathedral. There was little working of the stone on the island, however, because in 1851 it still had to be got down to the sea, loaded on barges, and carted to its destination, making the chances of damage very high.

In 1865, however, the Weymouth-Portland railway line was opened, and in

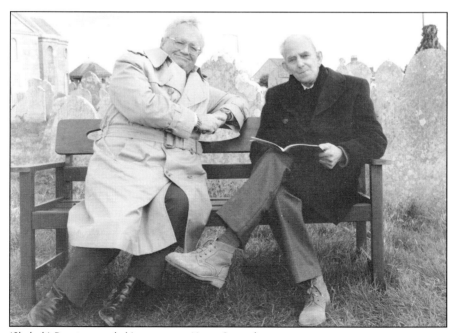

'Skylark' Durston reads his poems to Harry Secombe

A BIT OF A BUMBLE!

1900 a goods service to Easton. It now became possible to move the stone at little risk and, therefore, it could be worked on Portland itself. Masons poured in. Inevitably, the newcomers with their greater knowledge of the world were much resented by the Portlanders. In particular, the young men of the island found that they could not compete when it came to attracting girls.

Skylark wrote that in his verses he had 'deliberately avoided an excess of dialect in order that [the poems] might be more readily understood by the stranger within our gates'. Even so, there is here the authentic ring of local speech. The original punctuation (or absence of it) has been retained.

from **The Coming of the Masons or the Quarryman's Lament**

Take some whakin[1] do our Polly
I have knowed her all my life
Friendly sort and always jolly
Wouldn't mind her for my wife

I don't s'pose I'll ever have her
Thur be other chaps as well
Been sid[2] we some Mason feller
Lodgin, down round Fortuneswell

Nobody roun' yer ull 'ave em
Say they be a shiftless lot
Fond of drink and widder women
Everlastin, on the trot[3]

Course we tried to warn our Polly
Cussed and pleaded sighed and wept
Tried to make her see her folly
All the family was upset

But our Polly wouldn' t listen
Used to meet him just the same
And her eyes would shine and glisten
Even if I said his name

Mind yer he's a proper dandy
Tell the tale they say he can
With his tongue he's sort of handy
Easy get round Polly Ann

She do say that ee's good lookin'
I soon said what's wrong wi' me
Sooner go out conger hookin'
Than I'd bied and look at he

Always on about the Union
When I told our Mam she said
Better if he went communion
Knock some sense into his head

I don't think I'll ever marry
Tin so good as bread an' jam
I'll bide single like our Harry
Ain't I glad I got our Mam.

Notes:
1. **whakin** 'waking'?; perhaps waking up from her mistake?
2. **bin sid** 'been seen'
3. **on the trot**, i.e. moving about.

A BIT OF A BUMBLE CARTOON HISTORY BOOK

An Almost Totally INSANE DORSET

LOOK AT

British History

IN PICTURES

by Richard Scollins

Don' buy this book. T'is a load o' rubbish.

Yer I come.

I... WHO'S AFEARD? ...BE

Alfred and the Cakes — 878

Canute Demonstrates His Inability to Turn the Tide — AD 1020

Lady Godiva — 1057

The Battle of Hastings — 1066

The Death of William Rufus — 1100

King John and Magna Carta — 1215

**Edward I Presents His Son as
Prince of Wales — 1284**

Bruce and the Spider — 1306

The Battle of Agincourt — 1415

Richard III at Bosworth — 1485

Henry VIII and Anne Boleyn — 1529

Raleigh and the Puddle — 1581

Francis Drake Goes Bowling — 1588

The First Night of 'Hamlet' — 1601

The Gunpowder Plot — 1605

The Execution of Charles I — 1649

**Charles II and Friends Hide From
the Roundheads — 1651**

Isaac Newton Discovers Gravity — 1666

**Bonnie Prince Charlie Arrives
in Scotland — 1745**

Nelson at Trafalgar — 1805

Wellington Inspects His Troops — 1815

The Charge of the Light Brigade — 1854

Stanley Greets Dr. Livingstone — 1871

Queen Victoria 'Not Amused' — 1878

BIBLIOGRAPHY

Attwell, James: *Dorset Dialect Days*, 1987.

Barnes, William: *A Glossary of the Dorset Dialect*, 1886, repr. 1970.

Chandler, John: *Figgetty Pooden, The Dialect Verse of Edward Slow*, 1982.

Creed, Sylvia: *Dorset's Western Vale*, 1987.

Durston, C. A.: 'Skylark', *Tales from The Ragged Louse*, 1987.

Eady, Irene, A.: *Jottings from Puddletown*, 1999.

Mansel-Pleydell, J. C. (Ed.): *Robert Young, Poems in the Dorset Dialect*, 1910.

Jones, Bernard: *Collected Poems of Willam Barnes*, (2 vols) 1962.

Palmer, Kingsley: *Oral Folk Tales of Wessex*, 1973.

Read, John: *Wold Ways A-Gwain*, 1914.

Rogers, Norman: *Wessex Dialect*, 1979.

Saville, R.J.: *Zum Lanc 'n Zayens*, 1996.

Udal, John Symonds: *Dorsetshire Folklore*, 1922, repr. 1989.

Widen, Bertil: *Studies on the Dorset Dialect*, 1949.

ACKNOWLEDGEMENTS

My thanks go to the following for their help: Henry Best of Ilminster, Somerset; Richard Burleigh of the William Barnes Society for advice on Edward Slow; Sylvia Creed for permission to reprint a passage from her book *Dorset's Western Vale*; staff at the reference section of the Dorset County Library; Valerie Dicker of the Dorset Natural History & Archaeological Society for processing photographs, and the trustees of the society for permission to reproduce them; Kate Hebditch, sometime Assistant Curator of the Dorset County Museum, for helping me to find photographs; the family of the late Eric Ricketts for permission to reprint some of his sketches; Joan Taylor, for permission to reprint the writings of her late father, 'Skylark' Durston.